Colored Glory

Create your own stained glass windows.

By

Liora Pelunsky

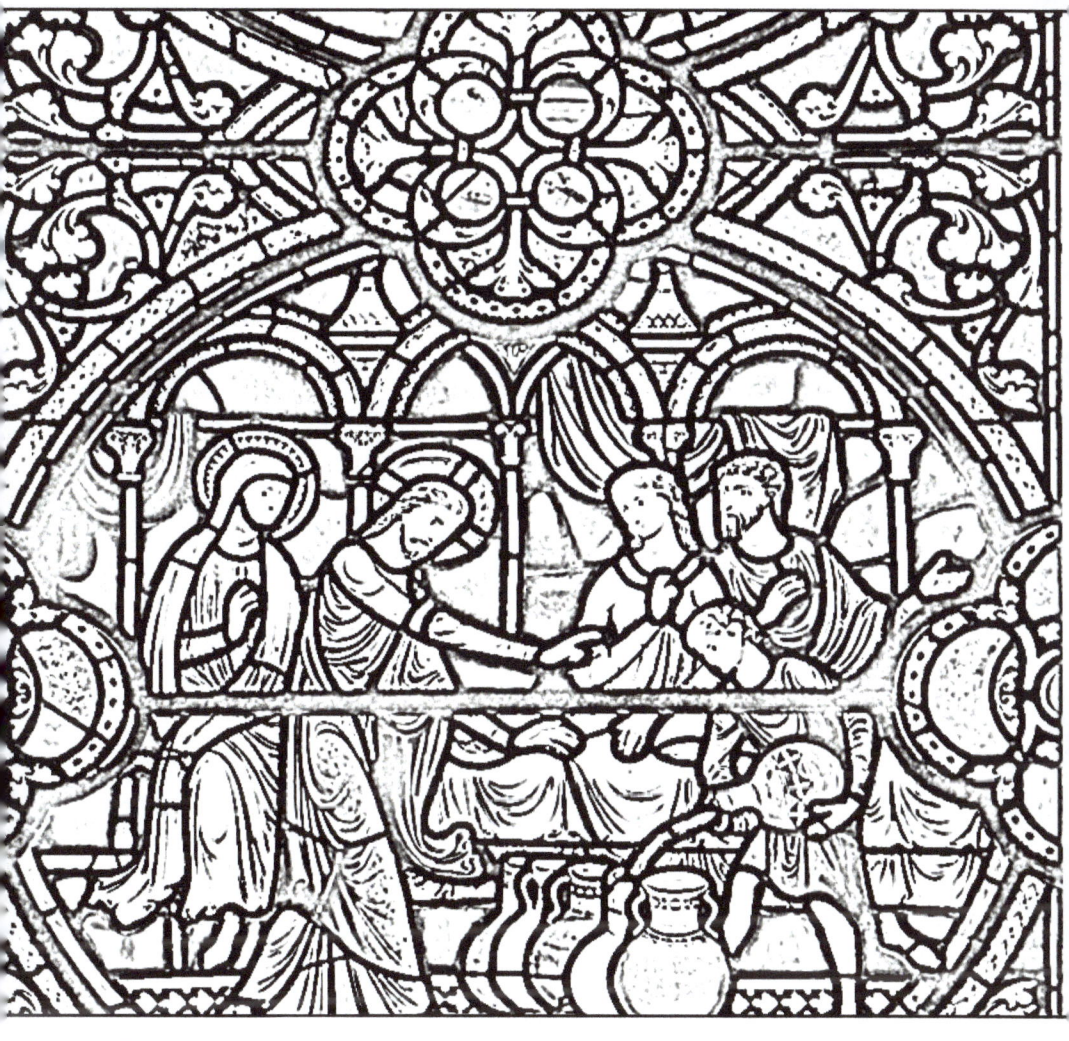

The art of stained glass reached its height in the Middle Ages when it became a powerful way to illustrate the stories of the Bible to a largely illiterate population.

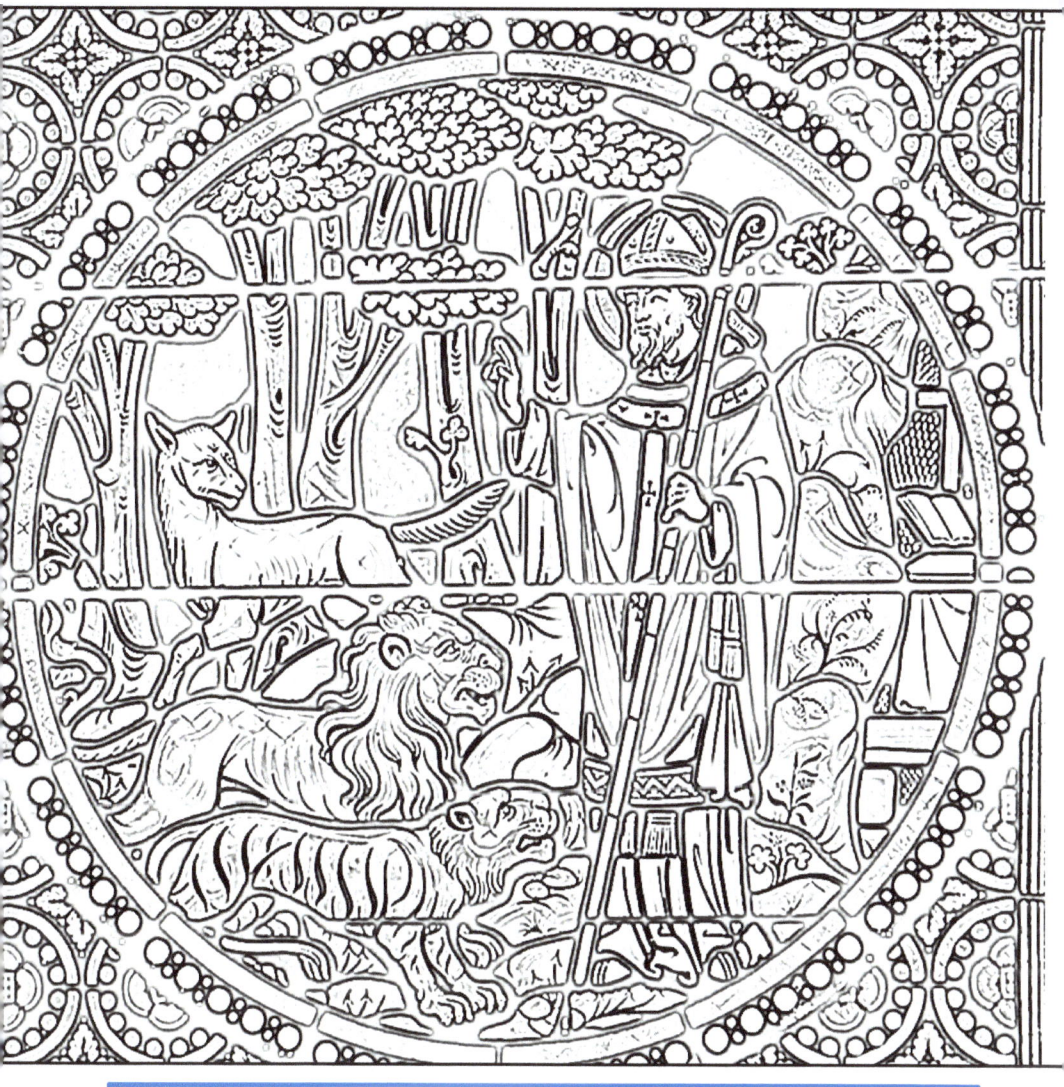

Chartres in France was the greatest centre of stained glass manufacture, producing glass of the highest quality.

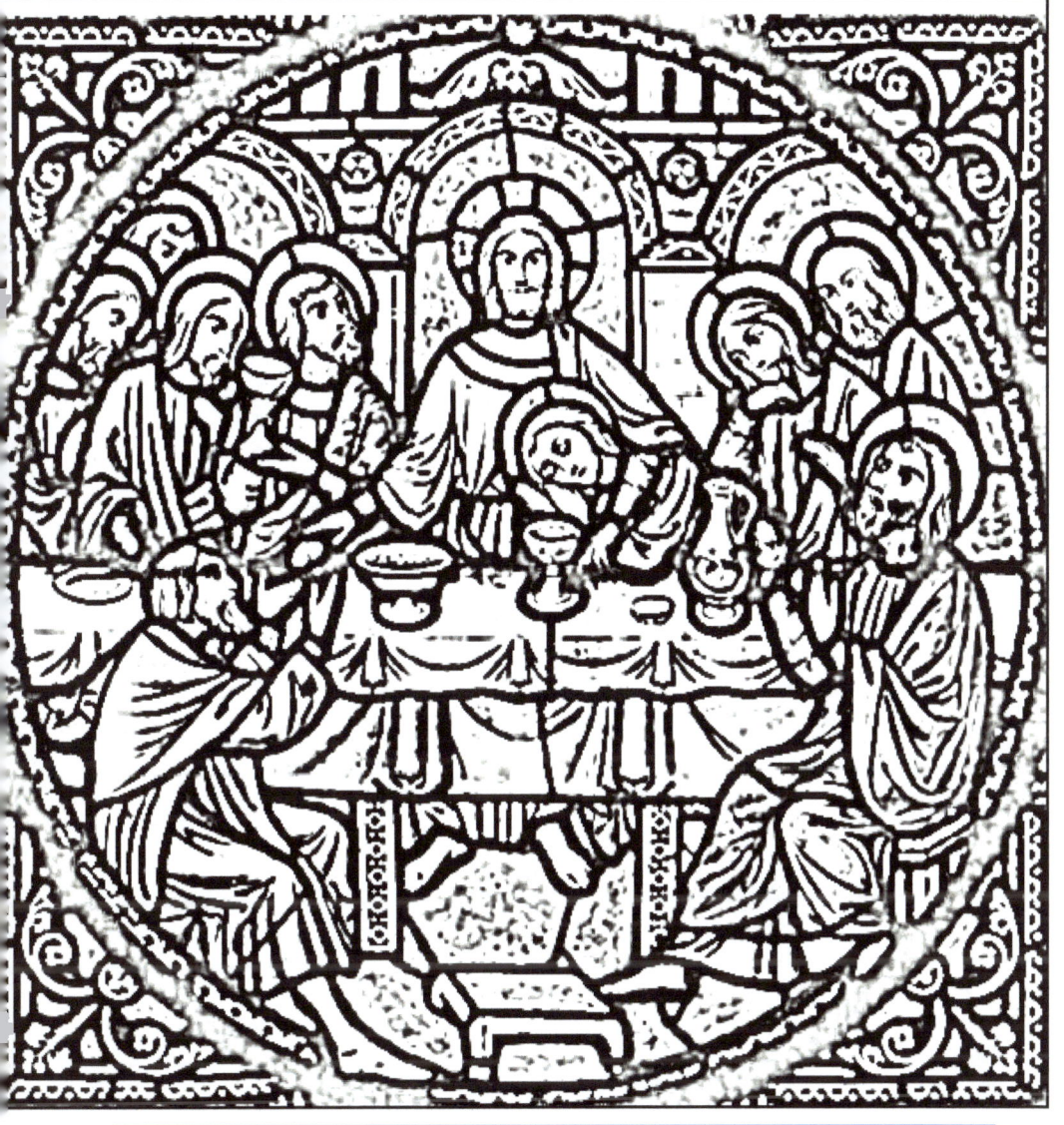

During the Renaissance stained glass continued to be produced with the style evolving from the Gothic to the Classical, which is well represented in Germany, Belgium and the Netherlands.

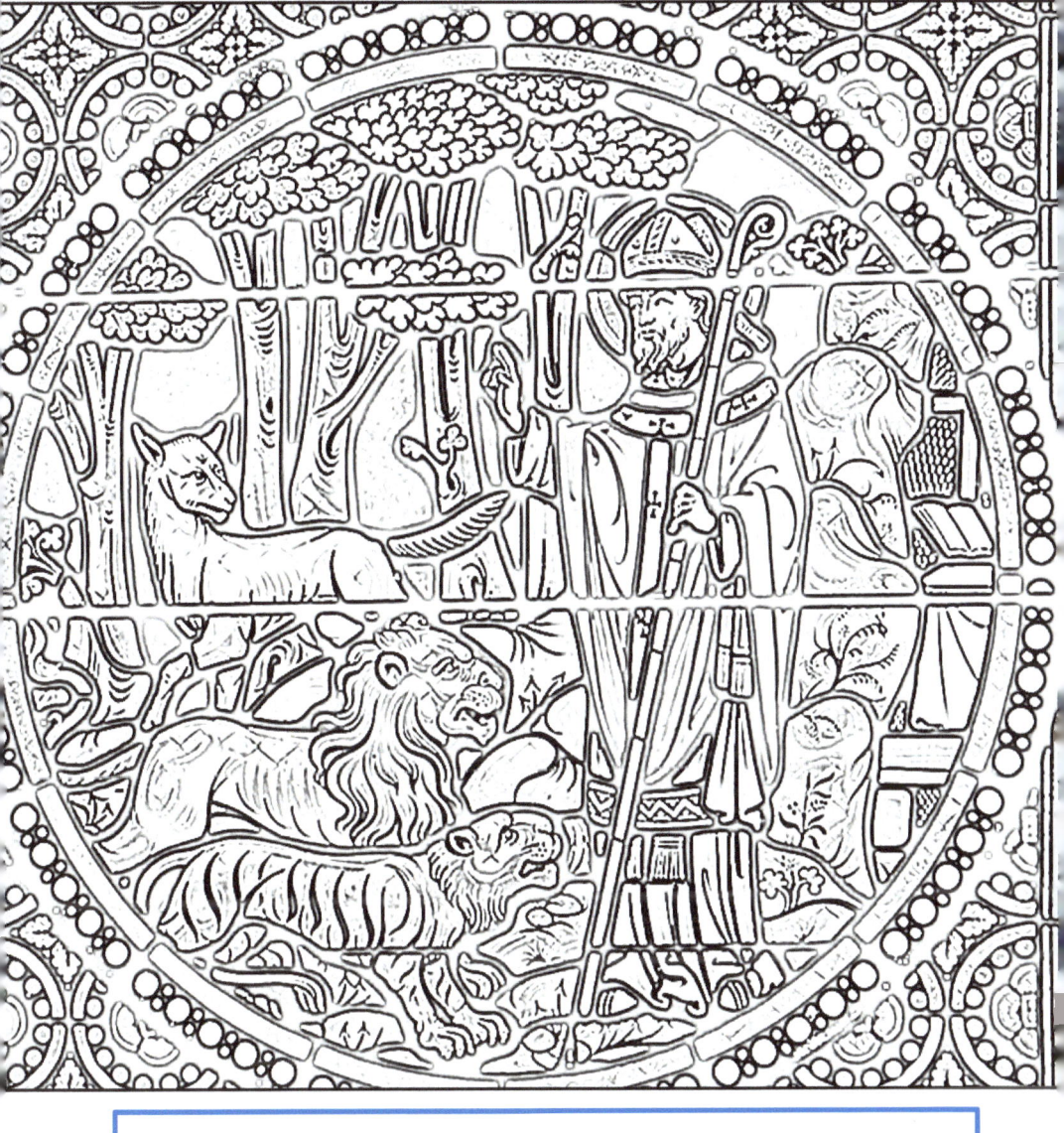

J&R Lamb Studios, established in 1857 in New York City, was the first major decorative arts studio in the United States and for many years a major producer of stained glass for churches.

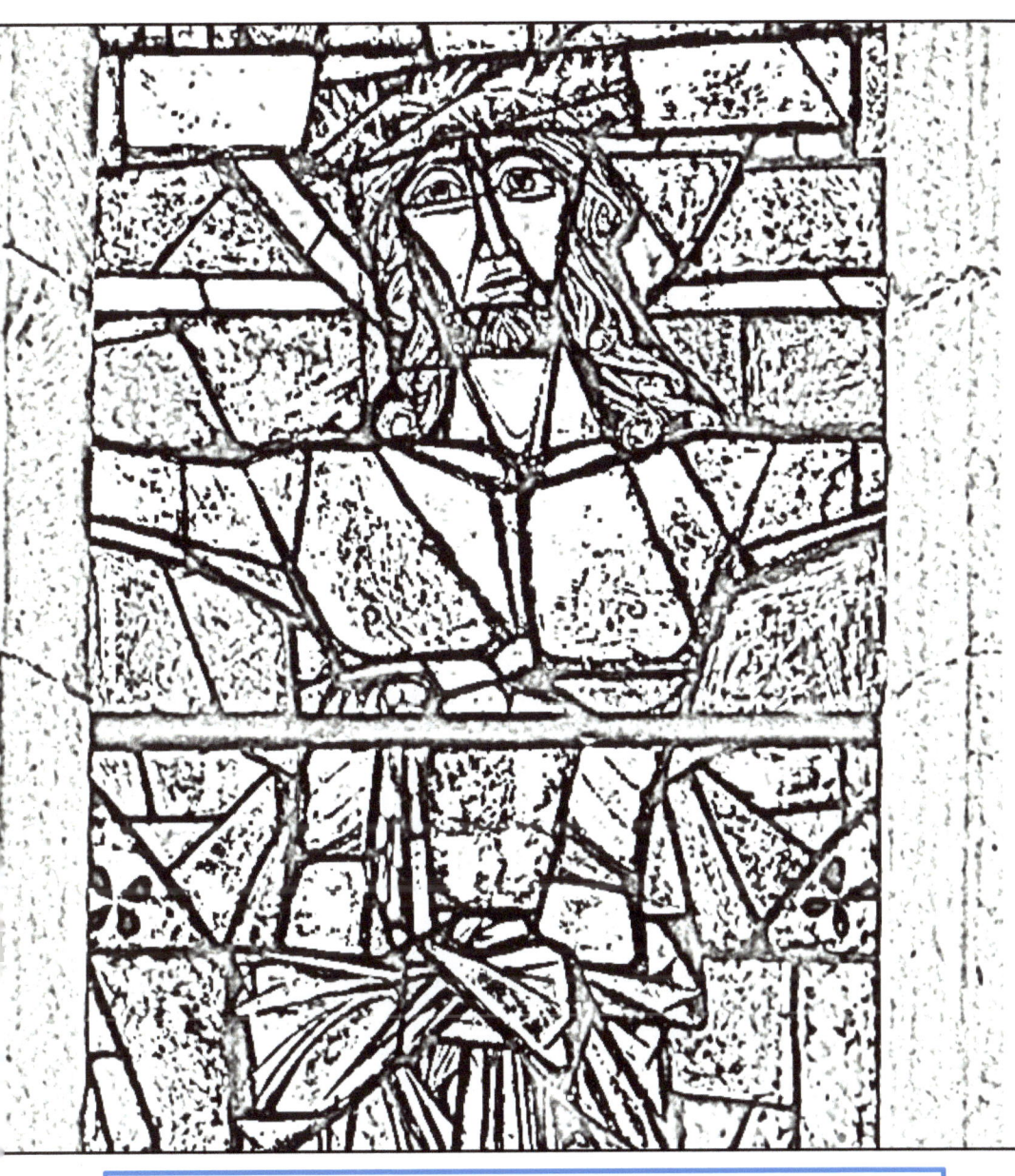

A revival occurred in the middle of the twentieth century because of a desire to restore thousands of church windows throughout Europe destroyed as a result of World War II bombing.

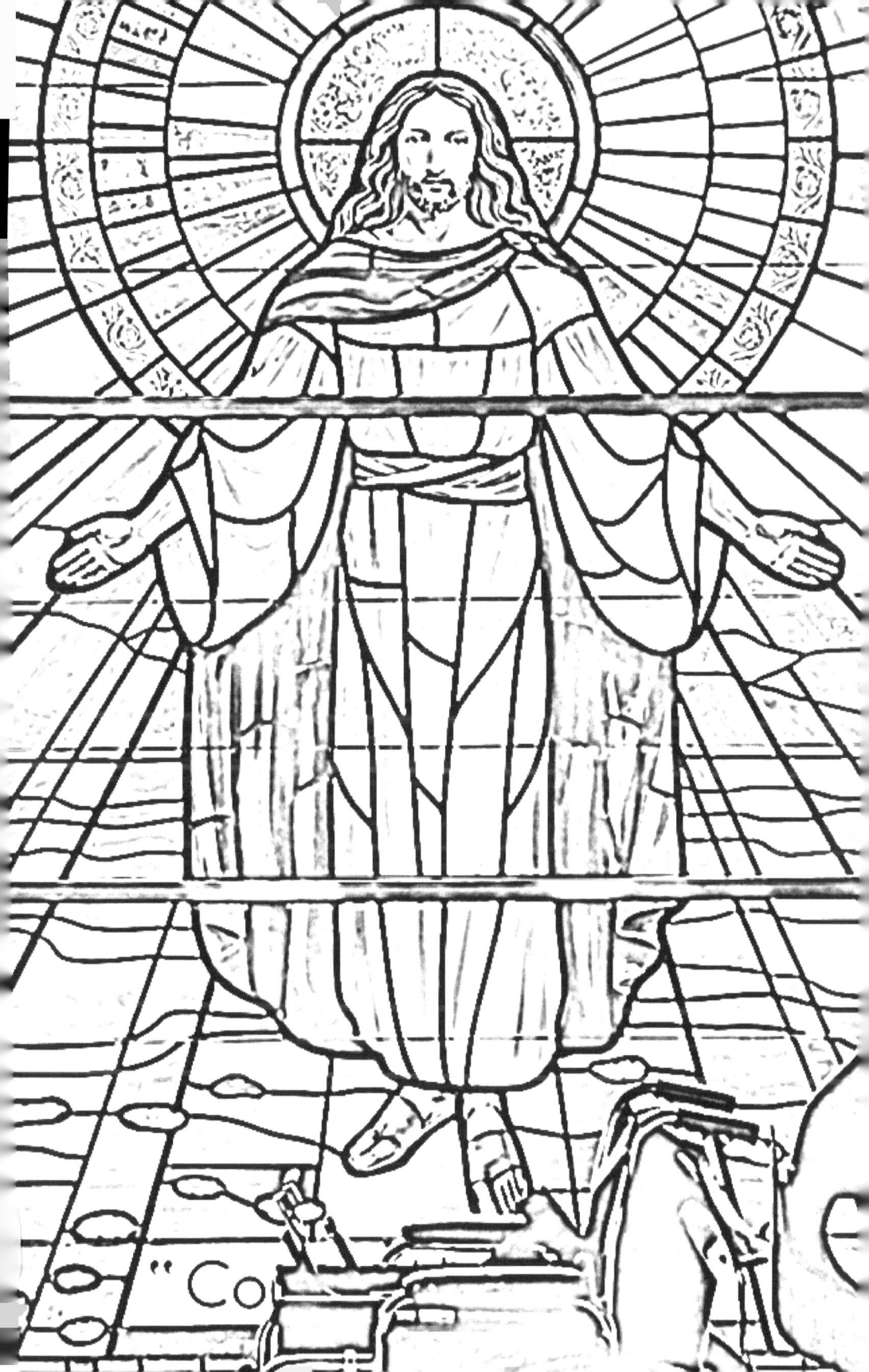

www.ingramcontent.com/pod-product-compliance
Lightning Source LLC
Chambersburg PA
CBHW041623180526
45159CB00002BC/993